H O W T O P A I N T

Miniatures

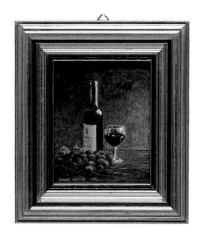

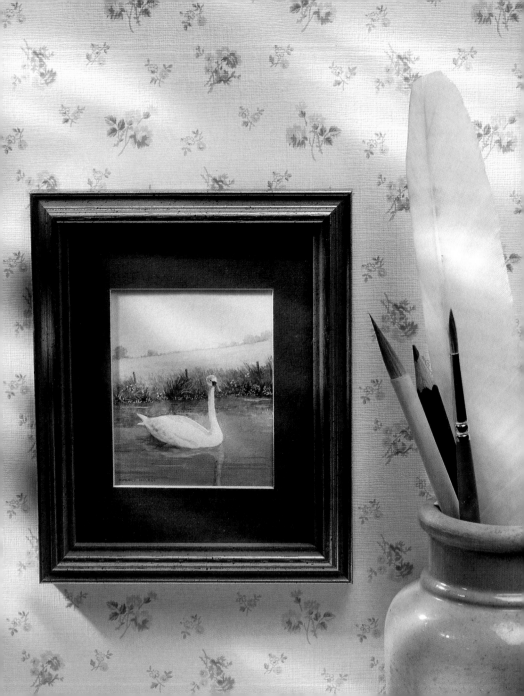

H O W T O P A I N T

Miniatures

ELIZABETH JOHNSON

AND

ROBERT HUGHES, R.M.S., H.S., S.M.

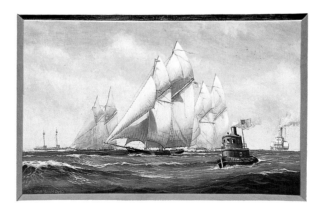

**CHARTWELL
BOOKS, INC.**

A QUINTET BOOK

Published by Wellfleet Press
114 Northfield Avenue
Raritan Center
Edison, N.J. 08818

ISBN 0-7858-0029-8

This book was designed and produced by
Quintet Publishing Limited
6 Blundell Street
London N7 9BH

Creative Director: Richard Dewing
Designer: James Lawrence
Project Editor: Stefanie Foster
Copy Editor: Lydia Darbyshire
Photographer: Colin Bowden
Additional photography: Nick Bailey

Quintet Publishing would like to thank
Cornelissen for supplying paints and equipment
for photography

Typeset in Great Britain by
Central Southern Typesetters, Eastbourne
Manufactured in Singapore by
Bright Arts Pte. Ltd.
Printed in Singapore by
Star Standard Pte. Ltd.

Contents

INTRODUCTION *6*

A BRIEF HISTORY OF MINIATURES *7*

MINIATURE PAINTING TODAY *12*

MEDIA, GROUNDS, AND MATERIALS *15*

WATERCOLOR *16*

GOUACHE *20*

OILS *22*

ACRYLICS *26*

PASTELS *28*

OTHER MEDIA *30*

PRESENTATION *32*

THE PROJECTS *35*

Portrait

A PORTRAIT OF SUE *36*

THE SQUATTER *40*

Land- and Seascape

A COUNTRY LANDSCAPE *44*

HARBOR SCENE *48*

THE FIRST TRANSATLANTIC YACHT RACE *52*

Still Life

WINE AND GRAPES *56*

STILL LIFE IN A NICHE *59*

Nature

ALL RIPE AND JUICY *63*

WILD ARUM LILY *68*

THE SWAN *73*

THE ARTISTS *76*

SOCIETIES *80*

Introduction

Interest in miniatures is growing throughout the world, as increased attendances and sales at galleries and exhibitions are proving, and there are many fine miniaturists working in a variety of styles and with different techniques.

The aim of this book is to provide the painter new to miniatures with an insight into the background of this art, and into its practicalities and intricacies. We also hope that art lovers who do not necessarily aspire to painting themselves will find enough to allow them to marvel at the skill, application of detail, precise composition, and infinite patience necessary to produce these small masterpieces.

We would like to thank those artists whose work is featured in this book for their time and their support. We hope that readers will be able to enjoy more of their work and the work of other miniaturists by visiting galleries and exhibitions, and thereby themselves contributing to the revival of this most fascinating and demanding of art forms.

A Brief History of Miniatures

The art of painting on a small scale in minute detail originated in Britain with the embellishment of manuscripts by limners. The name limner derives from the word limn (to paint), which, in turn, comes from the Old French *luminer,* and the Latin *luminare,* meaning to brighten or illuminate. The word "miniature" derives from the pigment red lead, minium, which the limners mixed with gold and applied to parchment or vellum.

The skill of the limners in the design and execution of capital letters was gradually extended to more elaborate paintings incorporating the coats of arms or portraits of the people concerned with the subject of the manuscript.

During the early 15th century the portraits were separated from the manuscripts, a change attributed to the Hornebolte family, who brought the traditions of the Ghent–Bruges school of illuminators to Britain, where Lucas Hornebolte (*c.*1490–1544) found work at the court of the Tudor king, Henry VIII.

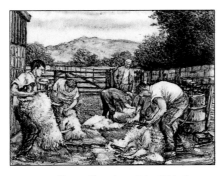

ABOVE Sheep Shearing, *Rita Whitaker*
RMS, SM. 2½ x 2 inches.

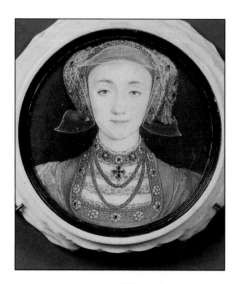

ABOVE Anne of Cleves *by Hans
Holbein (c.1497–1543); watercolor on
vellum set in a turned ivory box in the form of a
Tudor rose;* © The Crown

Hans Holbein (*c*.1497–1543) is considered to be the earliest painter of
miniature portraits. He succeeded Lucas Hornebolte at Henry VIII's court
and was given a wide assortment of tasks, ranging from designing court
costumes, silverware, jewelry and triumphal arches, to painting the
monarch's actual and prospective brides. One of his most notable paintings –
depicting Anne of Cleves – may be seen in the Victoria and Albert Museum,
London. It is thought that Holbein exercised a certain amount of artistic
license when he painted it. Henry had agreed to marry Anne of Cleves for
political reasons and on the basis of a portrait, which Holbein was sent to
Germany to execute. On their first meeting, however, Henry's expectations
of Anne's beauty were not fulfilled, and the marriage was quickly annulled,
Henry having referred to Anne as "the Mare of Flanders." What he said to
Holbein is not recorded.

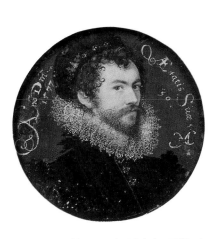

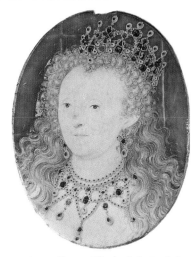

ABOVE Self-portrait by Nicholas Hilliard; painted in 1577; © The Crown

ABOVE Queen Elizabeth *by Nicholas Hilliard. The portrait depicts the aged queen in an idealized form, her loose hair symbolizing virginity. The painting was set in a case of gold, enameled in various colors and set with diamonds and rubies;* © The Crown

Nicholas Hilliard or Hillyard (*c*.1547–1619) was the first native-born artist of the British school whose work and life are reliably documented. The son of a goldsmith, he held a warrant as a goldsmith from Queen Elizabeth, but he is best known for his superb miniature portraits, examples of which may be seen in the Victoria and Albert Museum, London, and the Fitzwilliam Museum, Cambridge. Much of our knowledge of Elizabethan costume, jewelry, hairstyles, and symbolism derives from artists such as Hilliard. He particularly enjoyed simulating jewelry, *trompe l'œil* fashion, by mixing transparent pigments with a small amount of turpentine resin. The mixture was heated and laid over a burnished silver ground, creating the only raised part of the work. Sadly, the silver has deteriorated, spoiling many of Hilliard's works. At this time, the art of painting in miniature was a secret that was passed from father to son, or from master to apprentice. Hilliard himself wrote a treatise, *The Arte of Limning, c.*1600, but there is very little other recorded information about the early techniques employed.

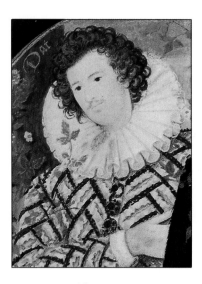

ABOVE Detail from Young Man among Roses *painted c. 1587 by Nicholas Hilliard (c. 1547–1619);* © The Crown

Other notable miniaturists following Hilliard's lead were Isaac Oliver (d. 1617), his son Peter (1594–1647), and John Hoskins (d. 1665), who became famous for miniature copies of works by Sir Anthony Van Dyck (1599–1641). Copying large portraits into smaller, more portable versions was a common practice in the 17th century to save the subjects from additional hours of sitting for the artists, but it is not encouraged today. Those painters who do attempt to copy should always credit the original artist in their own title. The miniatures executed at this time were portraits painted in watercolor on vellum (calfskin), and they were small enough to be carried in the palm of the hand. The technique used involved the careful blending together of layers of diluted color in minute detail, using tiny dots, lines, and hatching to create the different shades and tones.

Hoskins trained his nephew Samuel Cooper (1609–72) to carry on the art. Cooper's skill appears to have been limited to painting only the faces of his

subjects, but, according to the 18th-century English writer Horace Walpole, Cooper "first gave the strength and freedom of oil to the miniature." Executing miniatures in oil seems to have had only a brief period of popularity, however, largely, it seems, because of the limitations of the media then available – artists found it difficult to work in detail with the oil paints at their disposal, and many returned to working in watercolor and gouache. The availability of thin slices of ivory in the early 18th century introduced a popular base that brought a translucence to the paints used.

The art of detailed painting was transferred from portraits to scenes to decorate articles such as snuffboxes, and it was in the late 17th century that the word "miniature" came to be used to mean small painting. Miniatures were worn as ornaments, often in lockets studded with jewels, or they were displayed in cabinets. They were not usually hung on walls.

In the 18th century, the "eye" miniature came into fashion. The eye of the beloved was painted on an ivory snuffbox or set in a tiny pendant or bracelet, and they were sometimes worked in enamel or painted on porcelain before the process of firing.

In the mid-19th century, the art of the miniature began to decline. Artists were finding it harder to make a living as the demand for larger paintings increased, and patrons turned to less meticulous art forms. The development of photography gave miniaturists a temporary boost, for they were employed to finish the monochrome plates and to disguise them as miniature paintings. Cheap miniatures were produced by photographing images onto ivory, and these were then overpainted. Unfortunately, the photographic chemicals quickly destroyed the delicate pigments.

The decline of miniature painting was halted in the late 19th century by the formation in 1896 of Britain's Royal Society of Miniature Painters, the first society devoted exclusively to contemporary miniatures, and by the formation of the Society of Miniaturists. These societies, and others like them throughout the world, have helped to foster a revival in interest in miniature painting, and their membership is growing as more and more artists turn their talents to this demanding art form.

Miniature Painting Today

Nicholas Hilliard described the art of limning as "a thing apart from all other painting or drawing – and it excelleth all other painting whatsoever in sundry points." Whether today's artists would agree with this observation will depend on their own talents, styles, and preferences, but there are, nevertheless, many reasons for both beginners and established artists to take up the art of miniature painting.

The artist who chooses to work in miniature is able to experiment with a wide range of subjects, media, and backgrounds, in ways that are not available to painters who work on a larger scale. The smaller paintings also have other advantages: works can be completed comparatively quickly and for less cost. Although the speed with which paintings can be finished will, of course, depend on the complexity of detail and the individual artist's method of working, most miniature paintings can be completed in a single sitting, and it is certainly possible to execute studies and sketches very rapidly. The cost of materials and frames is proportionately lower than for large-scale works, and this is an important consideration for many artists. In addition, storage space is minimal, and there is no need to work in a large studio.

Miniatures are also easily transportable, and are light enough to be sent through the mail. In fact, most galleries and societies accept work by mail, although they will, of course, make a charge for returning unsold or unaccepted works. This ease of transport makes it possible for miniaturists to exhibit in distant towns and in other countries.

Every artist, either secretly or openly, wants to sell his or her work, and even those artists who paint as a hobby know that the best test of ability is whether the work sells. Exhibitions and galleries are an excellent way of selling works, and people who buy miniatures often become collectors, largely

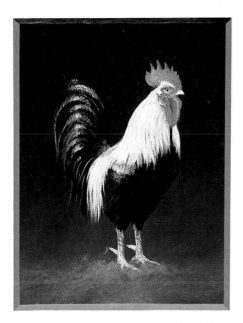

RIGHT The Gamecock, *Bev Taylor. 4½ x 6 inches. A favorite subject of artist and farmer Bev Taylor, giving him an opportunity to use many minute brush strokes to create the magnificence of this cockerel's plumage.*

because miniatures tend to look better when they are displayed in groups. Most miniature painters begin their painting careers by painting in more conventional sizes, and schools and colleges generally do not teach miniature techniques. The rudiments of the art are often learned, therefore, by studying finished paintings. Major salesrooms around the world organize sales of miniatures, and it is always worth attending previews, which offer almost unrivalled opportunities to study a wide variety of miniatures by different artists.

It is important to remember that miniatures are not just small paintings. All the standard rules of composition and perspective must be observed, but there is less room for error and the artist must adopt a tighter, more detailed style. The attractive quality of a miniature viewed from a distance is regarded to be just as important as the detail seen in the closest inspection.

The most widely accepted definition of a miniature is a painting of which the external dimensions of the frame do not exceed 7 x 5 inches. In general, the subjects of the painting should not exceed one-sixth of their actual size, although this guideline is difficult to maintain when small objects – seashells or mushrooms, for example – are painted, and the only internationally recognized rule is that a portrait head should not exceed 2 inches in height. Different societies have their own specifications for exhibiting artists, and it is important to familiarize yourself with those requirements before you submit work if you are to avoid automatic rejection. Britain's Royal Society of Miniature Painters (RMS), for example, sets a limit for rectangles and ovals of 6 x 4½ inches, including the frame, and 4½ x 4½ inches for square and round works.

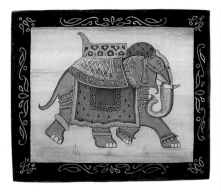

ABOVE Moghul Elephant, *Caroline Hayes HS. 3 x 2½ inches. Influenced by Indian miniatures, this charming elephant was painted in watercolor on ivorine, with a touch of gold leaf and a patterned border.*

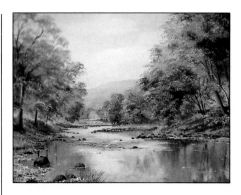

ABOVE Autumn in Upper Wharfedale, *John Dean RMS, SM, FRSA. 4 x 3 inches. This tiny landscape was delicately rendered in oil on ivorine.*

The medium used is left to the discretion of the artists, although photographic bases are not allowed. The materials and media now available, including new kinds of oil paints, allow today's artists to produce fine detail and soft blending in ways that were not previously possible.

Media, Grounds, and Materials

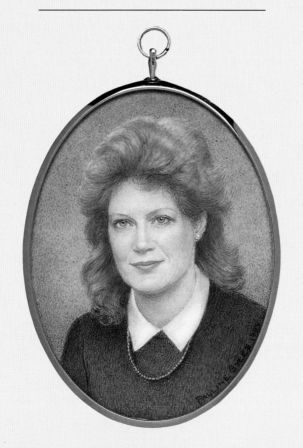

Watercolor

*Watercolor is probably the most popular medium for miniature painting,
although that does not necessarily mean that it is the easiest to use.*

When it is manufactured, the pigment is ground very finely and mixed with gum arabic, which dissolves in water and adheres firmly to paper or to any other suitable surface. The finer the pigment is ground, the better the quality of paint. The description Artists' Quality usually indicates the best watercolor paint, and because miniatures require fine detail, it is advisable to use the highest quality.

Watercolor paints are transparent, and in "pure" watercolor painting the surface is left untouched to show white or light areas. The color is built up by a series of washes, which are applied by painting from light to dark.

SURFACES

One of the traditional grounds for painting the finest miniatures is ivory, but ivory is almost impossible to find these days. You may come across articles such as old piano keys or boxes that, after sanding down, produce a fine surface to work on. Because of the rarity of ivory, many miniaturists have used a manmade substance over the last 80 years. This celluloid-like material, which was called ivorine, was the first practical, manmade plastic material to be developed as a substitute for ivory, horn, and tortoiseshell. As new plastic materials have been developed, the demand for celluloid has diminished and production is now limited. Ivorine is made in thin, flat sheets that have a matte surface on both sides, which retains watercolor without absorbing it. The sheets are a soft, translucent white, very similar to ivory, and are easily cut to shape. Although most artists have not experienced problems with miniatures completed on ivorine, there have been some reports of paintings buckling and warping within their frames. The manufacturers of ivorine do not agree on the reasons for this problem, nor on

what can be done about it. They point out that celluloid changes dimensions if it is subjected to extremes of temperature and humidity, and that, like most plastics, it must be allowed to move with changing atmospheric conditions. Ivorine should not be held in a picture frame in such a way that it cannot expand or contract. Correct storage of the product in a sealed polythene bag, preferably under a weight, is also recommended.

Lumitex is made by companies engaged in the production of materials for archival, restoration, and conservation use only. It is 100 percent acid-free, and has a constant pH; its color tone and texture are similar to ivory. Lumitex has only recently become available, and it is not yet certain that it will be suitable for fine miniatures.

For watercolors in particular, the painting surfaces must be perfectly clean. Some people recommend rubbing the surface with a piece of white bread to remove traces of grease, while others clean the surface with diluted dishwashing liquid, drying it thoroughly with a sheet of paper towel.

Vellum, which comes from the prepared skin of an aborted calf before the hairs have started to grow, was originally used by monks for their manuscripts.

Like ivory and ivorine, vellum can buckle in the heat, yet it becomes flat again when the temperature returns to normal. Do not allow the surface to get too wet, or it will become raised and spoil. Tiny blemishes from embryonic hair roots may be visible, and these give the surface a slightly uneven look. Treated with respect, care, and skill, vellum can help to produce the finest traditions in miniature painting that will last for centuries.

Because vellum, ivory, and ivorine are semi-transparent, they are best mounted on card before painting begins.

Paper is a popular ground, and it is recommended for beginners because it is also the cheapest. There are many different makes of paper, but the main qualities to look for are thickness (weight) and smoothness of surface. A smooth surface is essential, and a hot pressed (HP) paper of at least 140 pounds is best. It is more economical to buy large sheets, which can be cut down to provide enough paper for many paintings. Other surfaces, such as Bristol Board and Ivorex (a smooth, white cardboard), are suitable for miniatures.

IVORINE

GLASS PAPER

VELLUM

EQUIPMENT

The most important part of a miniaturist's equipment is the brush. Miniaturists use a surprisingly large range of brushes, but the most popular are those made of pure sable. The smallest brush is size no. 000, and they then range upwards through numbers 00, 0, 1, 2, and so on. Beginners should buy at least one no. 000, a no. 0, and perhaps a no. 2 to begin with. The finest brushes cost the most money, but if you use watercolor the best sable brushes will last a long time if you care for them properly.

Other brushes made from manmade fibers may be useful for larger washes or blending. Most artists collect brushes and are reluctant to discard any, even when they are worn. Some painters use old brushes for special techniques such as stippling foliage.

It is worth mentioning that caring for your brushes is vital. Apart from the saving you will enjoy by extending the life of a brush, broken hairs or tiny pieces of old dried paint can ruin delicate work. After use, always rinse your brushes in water, then wash them in soap or detergent, before rinsing them again in cold water. Do not use hot water because this could expand the metal ferrule that holds the hairs and thereby possibly cause the hairs to loosen. After washing, the brush should be carefully wiped to a point and left standing upright in a jar.

TECHNIQUES

Because watercolor is a transparent medium, you should always paint from light to dark in washes. Most of the techniques used in larger watercolors are applicable to miniatures, but one of the most important to the miniaturist is stippling or spotting. This involves the use of tiny dots of color at the detail stage, and it can give wonderful effects, especially in landscape painting.

It is advisable to use distilled water in preference to water straight from the faucet, thereby reducing the risk of small impurities spoiling the painting.

Gouache

Gouache is opaque watercolor, and it is often sold in tubes as Designers' Color. As with watercolor, the binding agent is gum arabic, but gouache also includes a white pigment, which gives the paint "body" and its opaque quality. For this reason, gouache is sometimes referred to as "body color." Because of its opacity, it is possible to paint light over dark and even to lay paint on thickly.

Gouache has been used by artists and illustrators since the Middle Ages, and it is thought to be one of the earliest media to have been available to painters. Today it is used mainly by commercial artists and book illustrators, but it is rapidly becoming more popular with artists of all kinds. It can be used effectively with watercolor, using the latter for the initial stages in washes, while the finer details are added in gouache.

SURFACES
The grounds previously described for watercolor paints can be used for gouache, but it is also possible to obtain different effects by using colored paper.

MATERIALS
The same range of brushes as used for watercolor also apply to gouache. In addition, a small (no. 1) round bristle or hog brush can sometimes be used, especially when paint is applied thickly.

TECHNIQUES
Although it is water-based, gouache has its own characteristics and differs greatly from watercolor in use. In can be used in flat washes, like watercolor, but practice is necessary to obtain the correct consistency. A light wash can be laid over a dark area to reduce the tone of a painting, but artists new to gouache may find it worthwhile to experiment with different colors and techniques. Gouache color tends to lighten when it dries, which can be disconcerting. Trial and error are the best ways to get the best from this medium.

Oil

Oil paint has been a popular medium for hundreds of years, and it is still one of the most widely used, although other media, such as acrylics, have gained support in the last 30 years.

Oil paint is made from pigment mixed with a vegetable oil, such as poppy or linseed, which dries very slowly. This may be one reason there are not many miniaturists working in oils, for the slow drying increases the risk of attracting dust, which can spoil a painting that has been worked on for hours.

The beauty of an oil painting lies in the richness of color and in the effects obtained from using different densities of paint and different techniques, such as glazing.

Oil paint is sold in tubes of different sizes. Again, Artists' Quality is the best and should be used for all miniatures, although, of course, you will only need the smaller tubes.

SURFACES

Oil paints can be used to great effect on ivory, ivorine, and vellum, although the latter requires sizing before painting. In addition to these, a large number of other surfaces are suitable for oil painting.

Canvas boards are not suitable for miniatures because the surface is too rough, but other prepared boards are ideal, and these can easily be cut with a knife to the size required.

Wood is an excellent ground for oils, but it must always be sized or primed. The easiest primer to obtain and to use is acrylic primer, which is available in small tins from art suppliers and hardware shops. Mahogany is the preferred wood for oils, and mahogany-faced plywood is also

recommended. You should apply at least two coats of primer, and this should be thoroughly sanded between coats. Hardboard is also suitable, and is much cheaper than other grounds. Although it also requires priming, hardboard is recommended for beginners.

Paper can be used if it is prepared on both sides with a shellac varnish.

Copper is an ideal surface for oils, and it has the advantage of being virtually indestructible. However, it is difficult to cut to size and rather expensive. No primer is required, but an undercoat of white makes it easier to draw a preliminary outline.

MATERIALS
The traditional thinners for oil paints are turpentine or linseed oil, or a mixture of both, but the resulting mixture can be rather slow drying. A modern alternative, a liquid alkyd resin, is available from art suppliers. It is quick drying, and very good for glazing and fine detail.

Brushes should be cleaned in a jar of white spirits during painting. The brushes used in oil painting include those previously mentioned, plus a few hog or bristle brushes and a fan brush for blending. There is also a very fine sable brush with shorter hairs, known as a "miniature," which can be very useful for the "spotting" technique.

Sable brushes are indispensable for oil miniatures, but they do not last as long as when they are used with water-based paints. It is worth taking extra trouble when you are cleaning them and after painting is finished for the day. All brushes should be first cleaned in white spirits, then they should be cleaned again in a proprietary brush cleaner before being washed in soap and water and thoroughly dried.

Other equipment useful for oil painting in miniature include tweezers for removing dust fibers, a small knife, and a sewing needle, which are used for removing small areas of paint. At least one palette knife

will be needed for mixing colors and, of course, you will need a small palette or piece of wood for laying out the paint. In miniature painting the palette is not held in the hand, but placed flat on the table, and the best shapes, therefore, are square or oblong, because they take up less room than conventional shapes. You will also need a small dipper or plastic container for the thinner medium.

One of the essential items for every oil painter is plenty of rags. These should be lint-free so that fiber particles, which are the curse of the miniature painter in oils, are not transferred to the surface. Paper towels are another useful accessory.

Some miniaturists use a small table easel on which to rest their work; others use a sloping board or simply rest the work flat on the table, but the choice is largely a matter of personal preference and experience.

TECHNIQUES

It is sometimes said that a completed miniature should have an entirely smooth surface, but applying this to oils denies the artist one of the most effective techniques – that of impasto, or thickly applied paint. This effect is perfectly acceptable in oil painting, and similar media paintings, in miniature, provided that it is in keeping with the subject.

Miniatures in oils can be painted *alla prima* (in which the painting is finished in one session), or by the more careful and considered approach of underpainting and glazing. For fine detail and "spotting" use a proprietary thinner and a very fine brush.

Before ending this section on oils, mention should be made of alkyd resins, which are very closely allied to oils and can be used with them. Alkyd paint is made from pigment mixed with a resin formed from a combination of alcohol and acid.

This resin is combined with oils that resist yellowing, and the end result is a paint with many of the characteristics of oils but with the great advantage that it dries quickly. Alkyds are workable on the palette for about four hours, and the painting is touch dry in 24 hours. This enables the artist to apply glazes and overpainting within a much shorter period, and retouching varnish can be applied in a few days after completion.

If you are using a combination of oils and alkyds, use the alkyds for underpainting and the oil paints for finishing. The surfaces, brushes, materials, and techniques used for oil paints also apply to alkyds. Alkyd paints have been available for about 15 years, so their permanence is not yet definitely known. However, from what is known to date, there is no reason to doubt that this medium is a useful addition to the artist's repertoire.

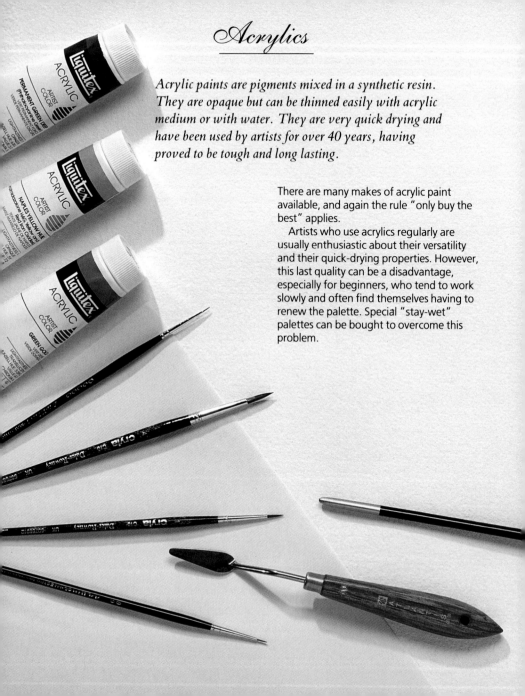

Acrylics

Acrylic paints are pigments mixed in a synthetic resin. They are opaque but can be thinned easily with acrylic medium or with water. They are very quick drying and have been used by artists for over 40 years, having proved to be tough and long lasting.

There are many makes of acrylic paint available, and again the rule "only buy the best" applies.

Artists who use acrylics regularly are usually enthusiastic about their versatility and their quick-drying properties. However, this last quality can be a disadvantage, especially for beginners, who tend to work slowly and often find themselves having to renew the palette. Special "stay-wet" palettes can be bought to overcome this problem.

SURFACES

Acrylics can be used on virtually any surface that is free from grease or oil.

Paper need not be primed, so it is an ideal surface for miniatures in acrylic. Wood and hardboard should be primed with an acrylic primer; do not use oil-based primers, because they will not bind with acrylic paint.

MATERIALS

Brushes are generally the same as those required for oil painting, but extra care must be taken not to let paint dry on the brush. It is best to stand the brushes in a jar of water while you are painting, and thoroughly wash them in soap and water when you have finished. If a brush does solidify with paint, soak it overnight in methylated spirits, work out the paint on a rag, and then carefully wash the brush in soap and water.

Palettes can be similar to those used in oil painting, but dried paint can be more easily removed from white plastic. It is worth investigating the "stay-wet" palettes at your art suppliers, but they are not essential.

Acrylics generally dry to a finish that is midway between matte and gloss, although some types of acrylic paints will provide a matte or a gloss finish, and these should not be thinned with water.

Plenty of rags and paper towels are essential for acrylic painting.

TECHNIQUES

Acrylic paints are versatile. They can be used in thin washes or applied as impasto. Like watercolors, they can be transparent when they are thinned with water or a thinning medium, although when they are used straight from the tube they are quite opaque.

The technique of painting wet into wet – that is, the mixing of colors on the painting itself – can sometimes be difficult because acrylics dry so rapidly. This can be overcome by using a retarder, especially made for acrylics, which is added to the color on the palette to slow the normal drying time.

Pastels

Pastels are powdered pigments mixed with gum or resin to make a paste – hence the word pastel – which is formed into sticks.

The use of pastels dates from the 18th century, but they are very popular today, especially for outdoor work, because they provide instant color without some of the paraphernalia necessary with other forms of painting.

They are not the ideal medium for miniatures, however, because it is difficult to achieve fine detail. Nevertheless, some miniaturists do choose to work and exhibit in pastel.

SURFACES

The surface is very important when pastels are used because it must be capable of retaining the grains of color. The special pastel papers obtainable at art suppliers can be bought in various colors, which helps to provide a suitable background, sympathetic to a particular subject. Very fine glass-paper is also a good ground for pastels.

MATERIALS

A good way to start is to buy a boxed set of pastel colors and to add to them as you gain experience.

Other essential items are a putty eraser, a torchon (a paper wound into a tube with a point, which is used for adding or removing color from a small area), and an aerosol fixative.

TECHNIQUES

Pastel color can be applied in many ways, including rubbing with the forefinger, using the torchon, and applying powdered color with a brush. A fine line necessary for miniature work can be obtained by breaking the pastel stick and using the edge of the broken stick. It is also possible to obtain pastel pencils, which are suitable for fine detail.

Use a putty eraser, a torchon or, in some cases, a dry hoghair brush to remove mistakes. Fixative, which is used to prevent color lifting from the surface, can be used at various times during painting so that fresh color can be superimposed.

Other Media

In general, miniatures can be executed in almost any medium, and it is worth experimenting to find the one that suits you. However, there is little virtue in producing a miniature in a difficult medium. The potential buyer of a painting is usually not interested in the various technical problems that have been overcome by the artist.

Another piece of equipment specific to the miniaturist is some form of magnification. This can be a simple magnifying glass held in the hand or a more elaborate device, such as a lamp incorporating a magnifier. Not all miniaturists use magnifiers, and it is best to begin without one if possible.

Because of the intricacy and detail involved and the need to keep a dust-free environment as far as possible, nearly all miniatures are completed indoors, preferably near a north-facing window. This does not mean, of course, that a miniaturist never goes into the countryside. Material must be gathered, preferably from life, so there is still a need for outdoor work, although painting a miniature *en plein air* is not recommended.

Any source of artificial illumination should simulate daylight as closely as possible. Until recently the best available was a cool, white fluorescent tube, but there are now bulbs and tubes that provide illumination so nearly approaching daylight that the artist can paint in their light as in daylight. Sometimes two angled desk lights can be used to eliminate shadows.

Presentation

The way in which your work is finally presented is almost as important as the process of painting it. Beautifully painted pictures are often marred by being placed in the wrong frame or mat.

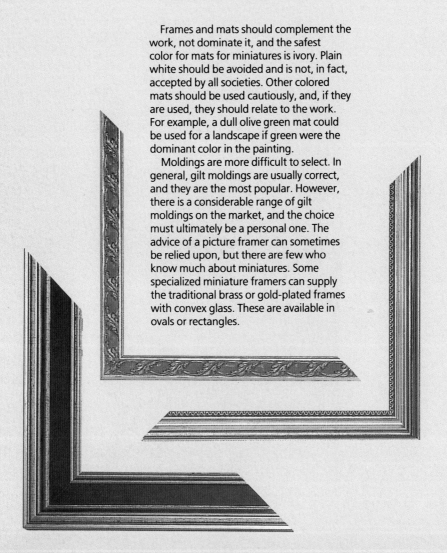

Frames and mats should complement the work, not dominate it, and the safest color for mats for miniatures is ivory. Plain white should be avoided and is not, in fact, accepted by all societies. Other colored mats should be used cautiously, and, if they are used, they should relate to the work. For example, a dull olive green mat could be used for a landscape if green were the dominant color in the painting.

Moldings are more difficult to select. In general, gilt moldings are usually correct, and they are the most popular. However, there is a considerable range of gilt moldings on the market, and the choice must ultimately be a personal one. The advice of a picture framer can sometimes be relied upon, but there are few who know much about miniatures. Some specialized miniature framers can supply the traditional brass or gold-plated frames with convex glass. These are available in ovals or rectangles.

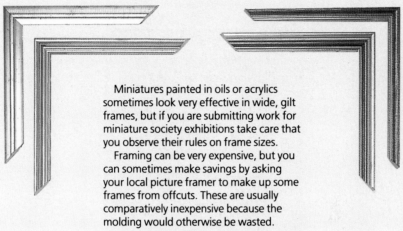

Miniatures painted in oils or acrylics sometimes look very effective in wide, gilt frames, but if you are submitting work for miniature society exhibitions take care that you observe their rules on frame sizes.

Framing can be very expensive, but you can sometimes make savings by asking your local picture framer to make up some frames from offcuts. These are usually comparatively inexpensive because the molding would otherwise be wasted.

When you have framed your work, make sure that the title is written on the back of the picture. Some artists find titling a chore, but buyers generally like a title to refer to and can sometimes be put off by seeing a work labeled "untitled." The reverse of a miniature should always be neatly finished. A work can be rejected by a selection committee if the back of the painting is left exposed, or if clear adhesive tape has been used. Brown gummed tape or paper adhesive tape give a very neat finish.

The presentation can make the difference between selling or not selling a work, and time spent on this aspect is always worthwhile. Pricing your work is always initially difficult before testing the market. In general, it is the talent and reputation of the artist for which the buyer is paying, and there is no reason a small painting should not cost as much as a larger one. The best way is to visit galleries and exhibitions, and assess for yourself the price range of your work.

The Projects

A Portrait of Sue — PAULINE GYLES

The Squatter — HEATHER O. CATCHPOLE

A Country Landscape — ROBERT HUGHES

Harbor Scene — FREDERICK CAMERON STREET

The First Transatlantic Yacht Race — GEOFF HUNT

Wine and Grapes — ROBERT HUGHES

Still Life in a Niche — BARBARA VALENTINE

All Ripe and Juicy — ERIC MORTON

Wild Arum Lily — VALERIE CROKER

The Swan — ROBERT HUGHES

A Portrait of Sue

PAULINE GYLES
3 ½ X 2 ½ INCHES; WATERCOLOR ON IVORINE

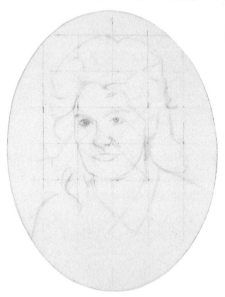

The subject of this portrait is a friend of the artist who did not have time to sit for a portrait for long periods. Pauline Gyles therefore used a photograph for the main part of the work, only referring to her sitter in person from time to time. She uses two no. 1 brushes – a miniature Series 12 sable and a Series 7 sable – both of which have very fine points. Before working on ivorine, Pauline Gyles cleans it with talcum powder on cotton wool, and then wipes it with a damp tissue or clean piece of cotton wool to provide a perfectly smooth and grease-free surface. She cuts the ivorine to size and, because it is translucent, attaches it to white cardboard to provide a good background to work on.

1. The photograph is squared up by drawing horizontal pencil lines across the top of the head and the bottom of the chin, and a vertical line at the side of the nose to indicate the central point. A further horizontal line is drawn midway between the top and bottom lines so that the face is divided into four equal sections. Additional equidistant vertical and horizontal lines and diagonal lines are added, and then the grid is transferred to the prepared ivorine, the distance between the lines being adjusted as necessary so that the head is centered on the ivorine.

2. Light red is used for the outline, and the features on the photograph are gradually transferred to the ivorine. It is easy to remove watercolor from ivorine if any mistakes are made. The outlines of the head and shoulders are carefully defined.

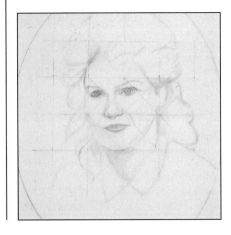

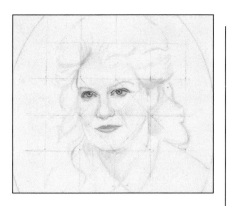

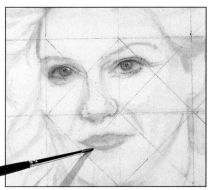

3. The eyes, nose, and lips, and the shadows around them, are painted in a series of little strokes to mold the outlines, and the paint is allowed to dry before another layer of color is added. Remember that eyes are round and must be shaded at the top. Remember, too, that the top lip is darker than the lower one – rose madder is used for the upper lip and vermilion for the lower. The nose and skin shadows are lightly painted with burnt sienna.

4. More work is done on the eyes and lips, and the first wash for the background is painted in yellow ocher, burnt umber, and cobalt blue.

5. The hair is painted in several washes with mixtures of Indian red, burnt umber, and sepia. Highlights and darker tones are worked in while the paint is still wet to soften the look. When you paint hair you must always consider the light source; in this painting it is the top lefthand side.

6. The first wash of ultramarine blue for the sweater is painted. Because the subject is wearing a gold necklace, this area is left unpainted. More washes are added to the skin, and further details are added to the eyes and lips.

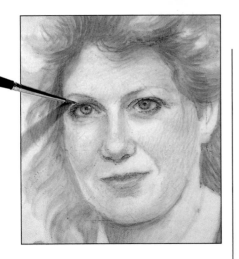

7. Although constant reference is made to the photograph, it is important to see the sitter at this stage to check that the skin tones and facial expression are accurate. The eyes are almost completed.

9. The area around the eyes is highlighted in a very light wash of a cool, slightly green tone to avoid a flushed look.

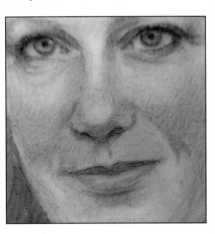

8. The skin is given a translucence by allowing the ivorine to show through. A little cerulean blue is used for the highlights in areas of darker tones – where the forehead meets the hairline, around the fold of the chin, and around the mouth, for example.

10. More work is done on the features. When the paint is completely dry the pencil grid lines are removed with a putty eraser or with a sharp blade.

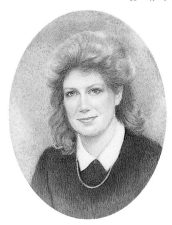

11. The background is built up with more washes. The blue of the sweater is deepened by at least four washes of a mixture of ultramarine blue, cobalt blue, and a little Payne's gray. The gold chain is given a first wash of yellow ocher. Making constant reference to the photograph, more detail is added to the lips and nose.

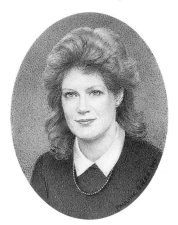

12. Darker areas are given further washes, and the chain is painted in yellow ocher, raw umber, and burnt umber. The background tone is deepened to contrast more strongly with the skin tones before the artist signs the painting.

13. The finished portrait is framed in an oval frame of the kind used by most miniature portrait painters.

The Squatter

HEATHER O. CATCHPOLE
4 X 3 INCHES; WATERCOLOR ON IVORINE

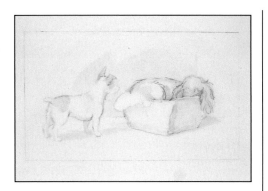

1. A light wash is painted in with a slightly heavier brush that has enough body to hold a considerable amount of paint. The wash indicates the main color blocks, deep shadows, and the final colors that are going to be used.

After deciding on the composition, Heather Catchpole drew a series of sketches from memory. She chose one of these and drew it in more detail on layout paper. She outlined it in ink, erasing the unwanted pencil lines with a small piece of putty eraser held in a pair of tweezers. She cut a piece of ivorine to size and used masking tape to hold it in place over the ink drawing, which she then traced on to the ivorine in light gray with a no. 00 Series 16 Winsor & Newton sable brush. A lightbox is invaluable for this. Heather Catchpole's palette consists of about 12 colors, and she sometimes also uses a little gouache.

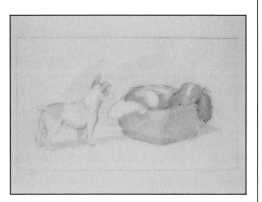

2. More line work is added with a hatching technique to begin bringing the details into the picture.

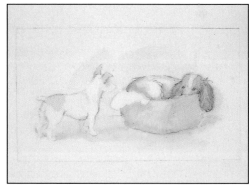

3. The dark areas are built up with more wash, and a color wash is introduced to the lighter areas.

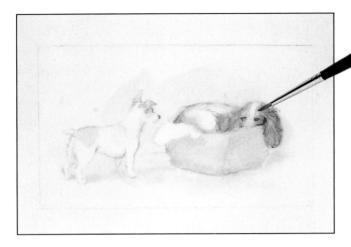

4. The base of the floor color is applied as a wash, and the spaniel's eyes are painted in. The exact position of the eyes may be changed as the painting develops to make certain that they catch the correct expression – which is decidedly belligerent.

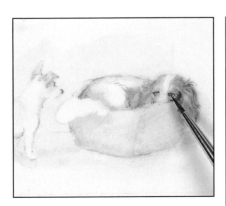

5. This close-up shows the detail being added to the eyes.

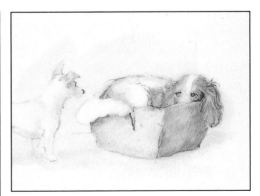

6. Color is added to the box to make it three-dimensional, and the first light and dark shades are added to the Jack Russell terrier.

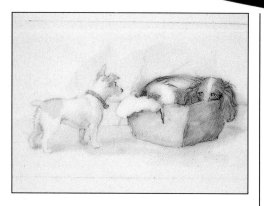

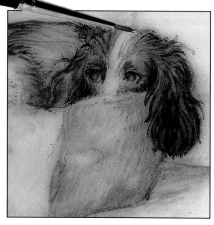

7. When watercolor is used on ivorine, corrections and changes can be easily made – the shape and position of the spaniel's body are slightly altered, for example. The tones on the terrier's body are built up, and the background detail is added.

9. This close-up shows the detail of the hair and eyes of the spaniel.

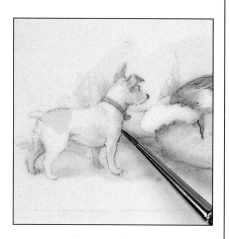

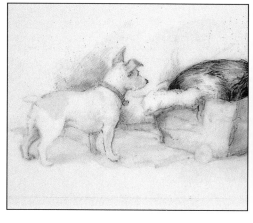

8. Details are added to delineate the terrier's body and to define the background.

10. It is important that the terrier stands out from the background, and shadows are used to round out the shape.

11. A ball is added to provide some color, and the position of the crack in the cardboard box is adjusted to balance the ball.

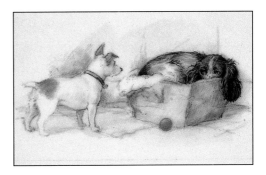

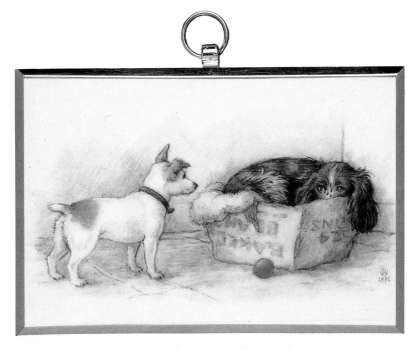

12. The finished picture, with some final details, such as crisping up lines, darkening the corners, and adding white highlights, and a signature. It is always best to leave a painting for a day or two before adding these finishing touches.

A Country Landscape

ROBERT HUGHES

2 ¼ X 4 INCHES; OIL ON BOARD

Country landscapes are always popular subjects, and the important factors to bear in mind are the need to use the elements of the scene to create an interesting composition, and to decide on a particular time of year and to make sure that the light and foliage are consistent with the season that is being depicted. This subject was chosen to illustrate the painting of summer foliage at midday. It is also important to determine the source of light – in this picture it is the sun, which is coming from the top righthand of the painting. Because it is not meant to be a specific place, Robert Hughes has included details from several photographs and sketches in the composition. His palette is based on eight "earth" colors – yellow ocher and burnt sienna, for example – supplemented with black and white.

1. A 3H pencil with a sharp point is used to draw the outlines lightly. The drawing is not done in great detail, but is intended to position the main elements of the subject.

2. The sky is painted in cerulean blue and titanium white. The clouds are white, tinted with a little burnt sienna and burnt umber, while those nearest the horizon are painted with ultramarine blue and a touch of cadmium red. The far distance is also shown, the hills being painted a deeper tone of ultramarine blue and red. The distant fields are terre verte with a little burnt umber, toned down with white. The background trees are in ultramarine blue and yellow ocher.

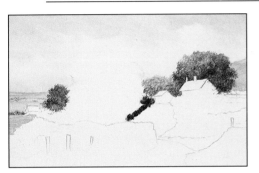

3. Once the background effects have been created, the middle ground is formed. The trees are filled in, using ultramarine blue and cadmium yellow to give the general shape of the foliage. Several brushes are used, including bristle. It is important to take care with the overall tone of the painting, and the dark colors should not be too deep or there will be no perspective.

4. The trees are given more shape and dimension, with a mixture of terre verte and burnt umber being used for the darker tones. A bristle brush is used to apply highlights on the foliage in a mixture of cadmium yellow and white with a touch of cerulean blue. Fine, visible branches are added with ivory black and raw umber.

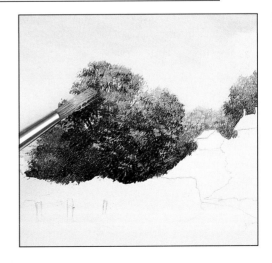

5. Burnt umber and white are used for the buildings and walls, with touches of ultramarine blue and raw umber in the shadows. Windows are spotted in with a fine brush in black and ultramarine blue. Red and browns on the roofs add warmth.

6. A variety of greens is used for the grass and bushes in the foreground; the greens are mixed from ultramarine blue, cadmium yellow, terre verte, and raw umber. More detail is needed as the painting moves nearer to the viewer, and smaller brushes are used for the "spotting" technique to add highlights in the hedges.

7. The foreground is completed by painting the road white with touches of burnt sienna and burnt umber. The fence posts are added to give shape to the road, which is further defined with spots of burnt umber and white. The light striking the fence posts is shown by white mixed with a touch of burnt sienna.

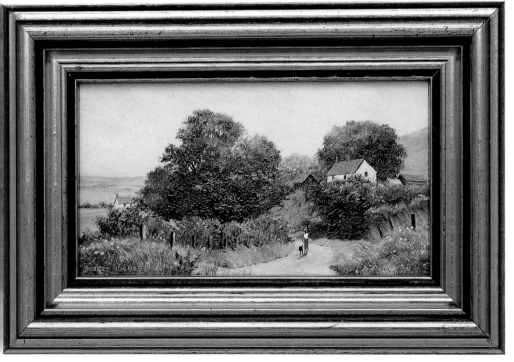

8. Flowers are painted in a variety of pure colors, and the figure and the dog are added to provide movement and interest. It is important that figures in a landscape are carefully placed and do not become so large that they dominate the landscape and detract from it.

Harbor Scene

FREDERICK CAMERON STREET
3 ½ x 2 ¼ INCHES; WATERCOLOR ON PAPER

The subject of this painting is a typical Cornish fishing village, which was painted from memory. The focal point of the painting is the fisherman's boat, and the scene includes the early morning light on the water, the boats, and the harbor cottages. Frederick Street was aiming to achieve an atmospheric painting with tonal perspective but without overworking the painting. He chose to work on 140-pound Lanaquarel paper.

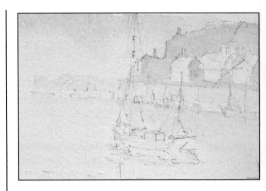

2. The sky wash was left to dry before a warm wash of burnt sienna is painted over the harbor buildings and the reflections in the harbor water.

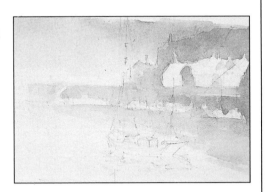

1. An outline drawing of the whole scene was done with a 2B pencil. Although the mast of the boat divides the painting into two equal parts, the weight of the harbor cottages tends to pull it towards the righthand side. Raw sienna and ultramarine blue are applied as a sky wash with a no. 4 round sable brush.

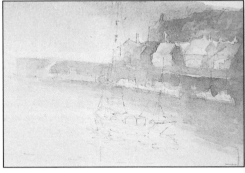

3. A pale wash of Prussian blue is painted over the original sky wash and over the buildings to create a subtle blue-green. The wash is deepened in tone as it moves away from the light source.

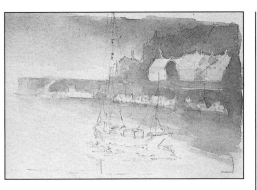

4. The Prussian blue is continued around and over parts of the distant boats and also into the harbor water. Another pale wash of raw sienna is played over the rooftops, previously left white, to show the effect of the morning light on them, and the same wash is used over the surface of the harbor water.

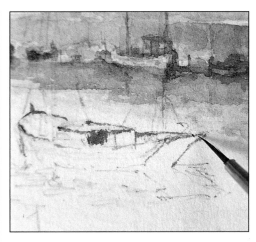

6. A close-up of the main fishing boat, with the outline being painted in with a no. 3 sable brush.

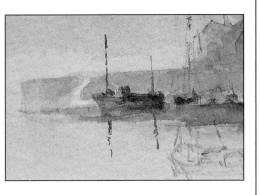

5. Only the shapes of the boats in the harbor are indicated by burnt sienna and Prussian blue, because few details will be clearly visible in the early morning light.

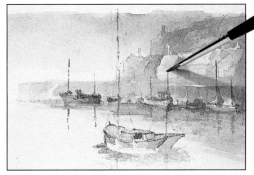

7. The positions of the masts are marked in, and the foredeck and cabin are painted with a pale wash of raw sienna. Cerulean blue is used to paint in part of the hull.

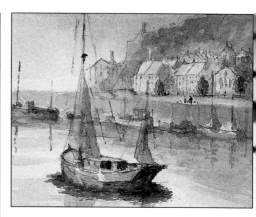

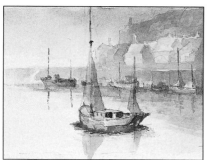

11. The cottages and buildings are shaped by marking in the windows and roof details and the harbor steps leading from one level to another. A no. 3 Pro-art sable brush is used to add trees close to the buildings and on the hills above.

8. The close-up shows the wash on the foredeck, cabin, and the hull.

9. The hull is overpainted with Prussian blue, and the color is taken over the angular stern. While this wash is still wet, a no. 3 brush is used to add an indigo wash to create a strong, dark tone, and some of this tone is allowed to go into the water around the boat.

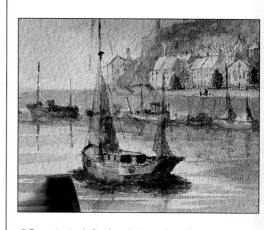

10. The mast is painted with raw sienna, and the sails are painted in a pale wash of raw sienna and alizarin crimson where they are lit by the morning light, and with indigo where they are in shadow. These colors are repeated in the reflections.

12. A ¼-inch flat brush is used to place a wash of olive green and raw sienna to define the surface of the water close to the boat. This deeper tone brings the fishing boat forward, and has the effect of pushing the distant boats farther away.

13. The close-up of the finished painting shows the background detail of the harbor cottages, figures, and boats.

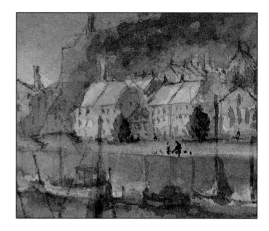

14. The orange floats are painted in cadmium and raw sienna, and highlights are added to the fishing boat.

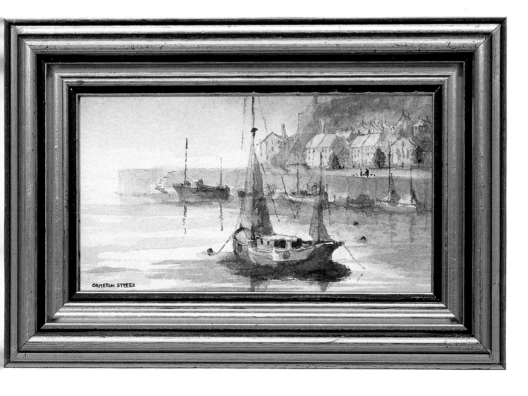

The First Transatlantic Yacht Race

GEOFF HUNT

6 ¼ X 4 INCHES; ACRYLIC ON BOARD

The subject was chosen chiefly because Geoff Hunt had a potential buyer in mind. The history of the event and illustrations were readily available, and it was a relatively straightforward task to compile a picture including the various yachts that took part. The inclusion of miscellaneous craft and the Sandy Hook light vessel both set the scene and create an exciting setting for the start of the race. Geoff Hunt used a palette including ultramarine blue, raw and burnt sienna, Payne's gray and Hooker's green, and before he began he carefully primed the board by rubbing it down to a very fine surface.

1. The first painting of the sea and sky is done with a hint of the wave and cloud formations. Geoff Hunt takes care not to let the paint build up too thickly, and he uses a light abrasive before overpainting to remove unwanted high spots and brush marks, which would otherwise subsequently show through.

2. The outlines of the yachts and other craft are drawn with an HB pencil; a softer lead would smudge and get into the paint. The vessels are painted in lightly, and details of the sea and sky are overpainted.

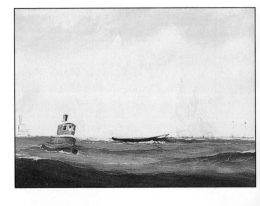

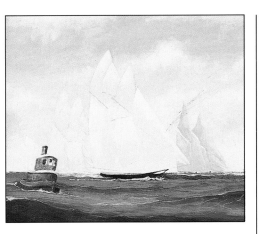

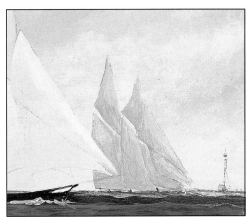

3. The clouds are painted in more detail so that they are almost complete before the vessels are added in detail. The dark areas of cloud are painted in ultramarine blue, Payne's gray, and a touch of burnt umber.

4. A close-up of the positioning of the leading yachts and the light vessel reveals the importance of distance perspective.

PAINTING THE SEA

𝒢eoff Hunt has painted the sea progressively as the whole work developed, sometimes working on it as a welcome break from the fine details of the yachts. The sort of sea is often predetermined in historical paintings, and the artist-mariner will generally, of course, have experience of a range of seas on which to base a painting. Other artists may base their work on paintings or photographs, although basing a detailed painting on a photograph may lead to the finished sea looking more like concrete than a complexly moving liquid. The palette required for seas is surprisingly varied, including not only ultramarine blue, Payne's gray, raw sienna and Hooker's green, but also hints of turquoise and crimson. Even in a miniature, the artist must be allowed a certain freedom if a lively and realistic sea is to be portrayed.

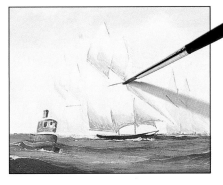

5. The details of the yachts' sails are refined as the shadows are built up by several overpaintings. Warmer colors are used for the sails in the foreground, while colder blues are used for those in the background to create a feeling of depth. Equally importantly, stronger tones are used in the foreground.

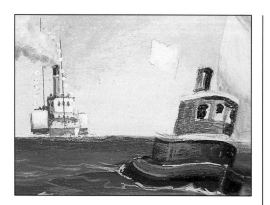

6. At this stage, as may be seen in this close-up, the tug and paddle-steamer are only sketchily indicated.

7. The sails of the nearest yacht show how the details of the shadow, sail seams, masts and yards, and flags and pennants are progressively built up.

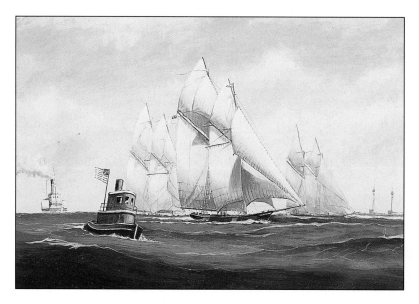

8. The picture is almost finished now, with the fine details of the rigging, smoke, flags and so forth completed, and the waves painted.

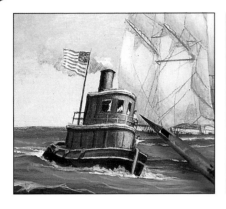

9. The close-up of the tug, with a no. 000 brush, reveals the details of the railings, figures, and flag.

10. Artists must know when to stop. Final details have been added – including, as an afterthought, the serial number of the tug – and some minor tonal adjustments have been made by light overpainting, but Geoff Hunt is sufficiently satisfied with the piece to have signed the work. Inevitably, there will be one or two final touches to make before the work is varnished.

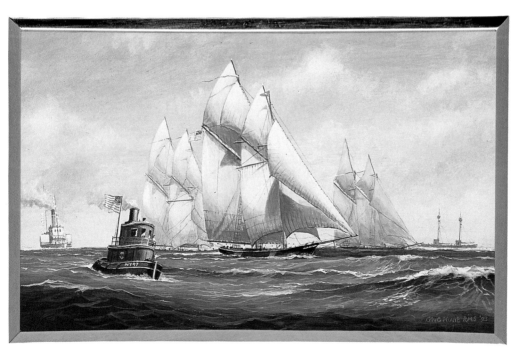

Wine and Grapes

ROBERT HUGHES
2 ½ X 2 INCHES; OIL ON BOARD

A still-life painting can be as complex or as simple as you wish. Most painters choose a still life for their first subject because there is such a variety of suitable objects available. Bottles, glasses, wooden items, and fruit and vegetables are all possible candidates, and they can be moved around until you find the right composition. This combination of objects was chosen for its simplicity and to illustrate the effects of light and dark areas. When you begin to work still-life paintings, it is best to have only one light source; light from two windows, for example, can be confusing for a beginner. In this painting the light is coming from the righthand side of the painting.

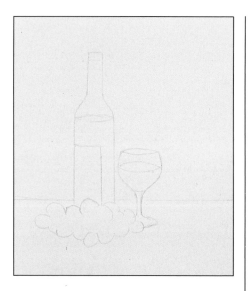

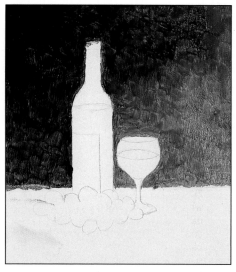

1. The outline is drawn with a 3H pencil. Robert Hughes finds that softer pencils are inclined to smudge and leave dirty marks.

2. The background is painted with a chisel-shaped sable brush, with ultramarine blue and raw umber used at the top. A mixture of burnt umber and yellow ocher together with some white is gradually blended in to lighten the righthand side.

3. The cloth is painted in terre verte mixed with raw umber. Because this painting is *alla prima* (that is, the final effects are achieved in the initial application of the paint rather than being built up layer by layer), the outlines of the glass, bottle, and grapes are described. A fan brush was used to blend the colors of the background and cloth, although any soft brush could have been used.

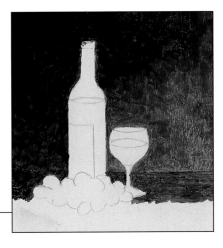

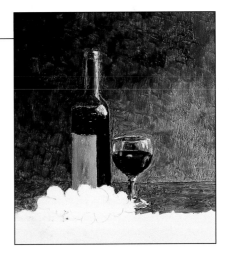

4. The top part of the bottle is painted in terre verte and burnt umber, with a touch of black added for the dark area. The rest of the bottle, the part containing wine, is painted in alizarin crimson and black. The label is painted white tinted with yellow ocher and raw umber. The light on the bottle is picked out in white, painted over while still wet, with a no. 000 sable brush.

5. The shape of the glass is defined in white on the still-wet background, and the darker areas are reinforced with raw umber and burnt umber. Alizarin crimson and black are used for the wine in the glass, and the reflections are achieved by using white tinted with blue. The stem of the glass is in white and terre verte, with burnt umber in the dark area.

6. The cloth is extended down to the grapes, which are themselves painted in ultramarine blue, alizarin crimson, with black and white used for the shade and light as necessary, and the light striking the grapes is carefully blended to simulate the velvety bloom on the fruit. The light on the cloth is blended with a soft brush to indicate the texture.

7. When the foreground is complete, additional details, such as the lettering on the bottle, are painted with a no. 000 brush, and the final light touches are applied, especially to the glass, bottle, and to the cloth.

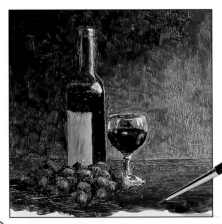

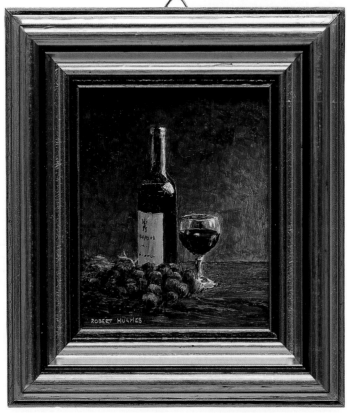

Still Life in a Niche

BARBARA VALENTINE

3 ¼ X 4 INCHES; WATERCOLOR ON VELLUM

A great deal of preliminary work is necessary before the actual painting of a still life can be started. Barbara Valentine first decided that the niche itself represents time/place/inter-personal relationships. The framework of uprights and horizontals counterbalances the subtle diagonals and curves formed by the objects she has selected and their relationships with each other. She made some preliminary sketches to work out tonal contrasts and patterns, and then did a color sketch to establish the main areas of color. At this stage, the items were about 5 feet away.

1. A frame was placed over the vellum to define the area of the miniature. The outline of the niche is drawn in background color, using the tip of a fine brush and fairly light watercolor, and the main objects are outlined in the appropriate color. At this point it is possible to remove outlines with the corner of a damp paint rag – for example, the first drawing of the frame of the marine miniature was moved slightly.

2. The main areas of color are blocked in lightly because using dark paint now would jeopardize the delicacy of the painting. The shadows are deepened, and the brilliance of the colors developed.

3. The objects are defined by darkening the shadows, which establish the pattern of the shapes between them.

4. The tonal contrasts are worked up to develop architectural shadows. It is important to look at the painting from a distance of several feet to make sure that the tone and pattern work. It is also helpful to turn it upside down in order to check that symmetrical objects have been correctly drawn.

5. Lines of color are used to provide harmonious curves and to lead the eye to every part of the composition. Another blue flower is added to create a blue triangle at the top of the arch.

6. The shadows are deepened, the edges of the images are sharpened, and the brilliance of the colors is further enhanced.

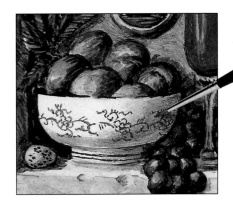

7. The pattern on the bowl and the spots on the quail's egg are added only when the shapes of the objects have been absolutely established by the shadows around them.

8. When watercolor is used on vellum it is possible to remove paint to some extent. Here the dark leaves in the lower lefthand corner have been adjusted in order to provide tonal contrast.

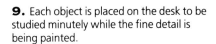

9. Each object is placed on the desk to be studied minutely while the fine detail is being painted.

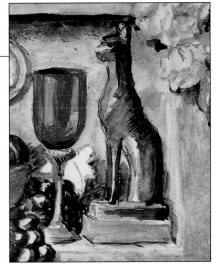

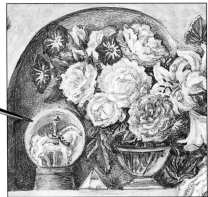

10. A little white can be used for highlights, but in general its use should be avoided.

11. When Barbara Valentine is entirely satisfied that all the detail is clear and accurate, she signs the painting and mounts it in a brass hanging frame.

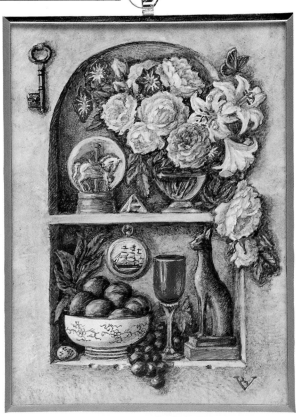

All Ripe and Juicy

ERIC MORTON
2 ¾ X 2 INCHES; WATERCOLOR ON PAPER

This subject was chosen for the color and contrast it offers. Eric Morton took the photograph on which the painting is based at a local fruit farm. His palette consists of Winsor & Newton watercolors in cadmium red, alizarin crimson, lemon yellow, cadmium yellow, yellow ocher, burnt sienna, viridian, chromium green, olive green, terre verte, cobalt blue, ultramarine blue, and a neutral tint. He modifies these with other colors as necessary, especially when he is painting botanical subjects, and he also mixes a tiny amount of gum arabic with the colors. Eric Morton tends to use the same molding to frame his paintings and prefers to complement them with a double mat, although this is not always possible because of restrictions applied by various societies regarding overall size.

He initially draws the outline of the composition with a 6H pencil onto tracing film, traces the outline on the back of the film, places it over the paper to be used, and goes over the first outline to transfer the lines very faintly.

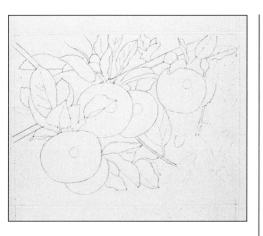

1. When he is happy with the composition, a fine outline is painted in with a no. 000 sable brush and very pale washes of the planned finished colors.

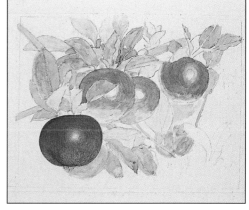

2. A rough wash is added with a no. 1 brush and the first apple painted, although no details are added yet. Once the outlines have been painted, the pencil lines are rubbed out with a plastic eraser.

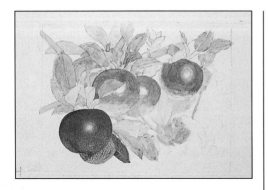

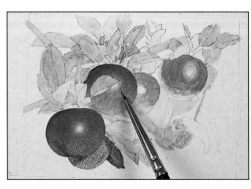

3. Another apple and a leaf are painted in behind the first apple, with shadows added with a hint of cobalt blue.

5. This close-up shows the detail being added with a no. 000 sable brush. The apples are painted in mixtures of cadmium red, crimson lake, cadmium yellow, and yellow ocher.

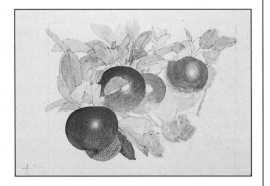

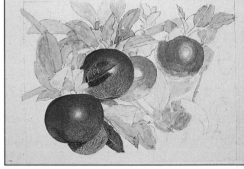

4. A third apple is painted, and a stippling technique and short strokes are used to add the first details.

6. The second apple and another leaf are finished, and neutral tints strengthened with cobalt blue are used for the shadows.

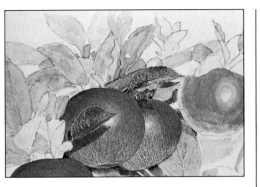

7. Further leaves are added above the apples by means of a stippling technique and olive green, viridian green, and terre verte modified with ultramarine blue to give a deeper hue. The third apple and the leaves around it are finished.

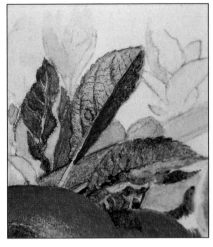

9. A close-up of the newly painted leaves.

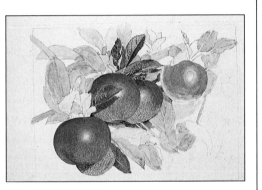

8. Leaves around the second and third apples are painted.

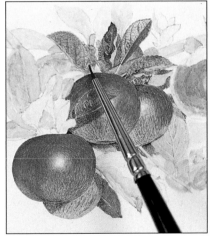

10. More leaves are added behind the apples.

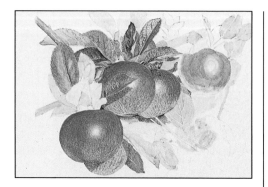

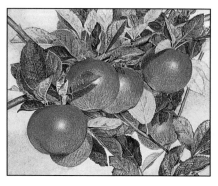

11. The depth and detail of the leaves are gradually built up, and the branch is carefully painted with a hint of terre verte and burnt umber.

13. The rest of the apples and most of the leaves and branches are painted. The highlights on the apples are created by leaving white paper showing through. At this point Eric Morton works on the painting as a whole, balancing up the overall image rather than concentrating on one or two sections.

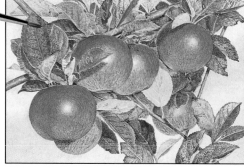

12. A detail of the leaves and the branch.

14. After a careful look at the whole composition, a few last refinements and details are painted in and the leaves are then finished.

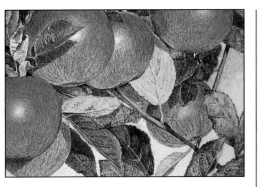

15. This detail of the center of the painting reveals the way shadows are used to give depth to the picture.

16. A close-up of the top righthand area of the picture shows the bloom on the apple and the details of the leaves.

17. The final painting, complete with the artist's signature.

Wild Arum Lily

V A L E R I E C R O K E R

2 ½ x 3 ½ I N C H E S ; W A T E R C O L O R O N P A P E R

Valerie Croker researches her subjects thoroughly, taking photographs or memorizing them from all angles for future reference. She selected the arum lily, which is a plant that grows in her garden, for this miniature because she is familiar with it and has often used it in her paintings. The painting was completed from memory. She began by pinning a large sheet of paper to a sloping board, resting her hand on the righthand side. The size of the finished piece was not predetermined, but evolved once she had decided on the position of the main subject.

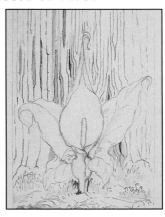

2. Background details are penciled in, and some foreground interest roughly added. Sepia and burnt umber are used for the bark, and lemon yellow for the moss.

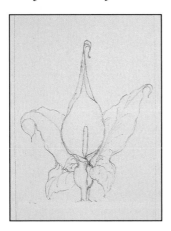

1. A B pencil with a very fine point is used to draw the outline of the main subject. This determines the shape and size of the finished work.

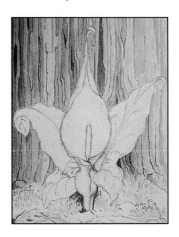

3. Various mixtures of brown and green are applied to the bark and the foreground. The aim is to build up a good, strong color in the background so that the main subject will contrast well.

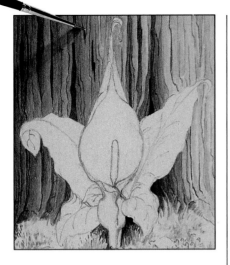

4. The paint is beginning to cover the pencil outlines of the bark and to reveal the shape of the main subject.

6. The close-up of the moss, tree, and leaves reveals how color and detail have been built up.

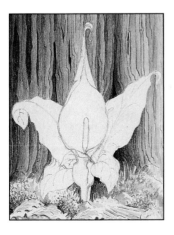

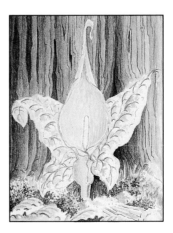

5. Payne's gray is added to the stones in the foreground. Green is added to the moss, and yellow ocher is used for the orange touches on the heads of the moss.

7. The spathe of the lily is worked in lemon yellow with a dash of olive green. Sap green is used for the leaves.

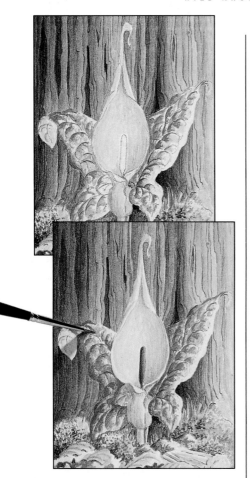

10. A no. 3 brush with a fine point is used to add burnt umber to the bark to give a deep, warm look.

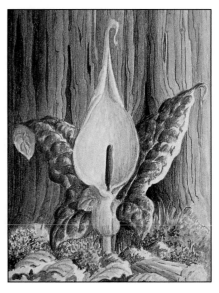

8. More green is added to the leaves, and more color is added to the foreground. Shadows are added to the spathe to show that the light is coming from the northeast.

9. The whole painting is beginning to take shape. More green is used to define the form of the leaves and the detail of the veins. The spadix is painted a mixture of crimson lake, sepia and violet, and extra shadow is added to the spathe to make the spadix stand out.

11. The spadix is completed with some additional shadow. Extra color is added to make the bark darker, olive green shadows are added to make the spathe three-dimensional, and more color is added to the leaves.

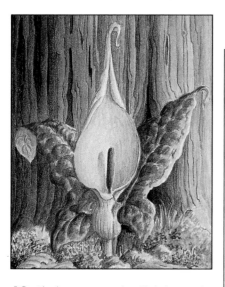

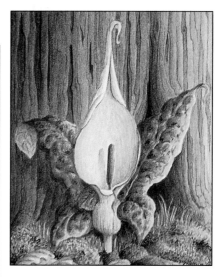

12. The leaves are made still darker, and all parts of the painting are brought to a finished depth of color, particular attention being paid to the moss, its orange head, and the dead leaves.

14. Red and purple dots are added to the leaves, and a fine red-purple line is painted around the spathe.

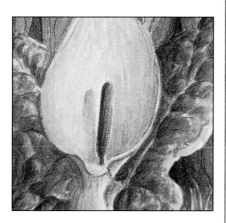

13. A close-up of the center of the plant reveals the deepening shadow playing on the spathe.

15. The close-up shows the texture on the leaves, and the line around the spathe.

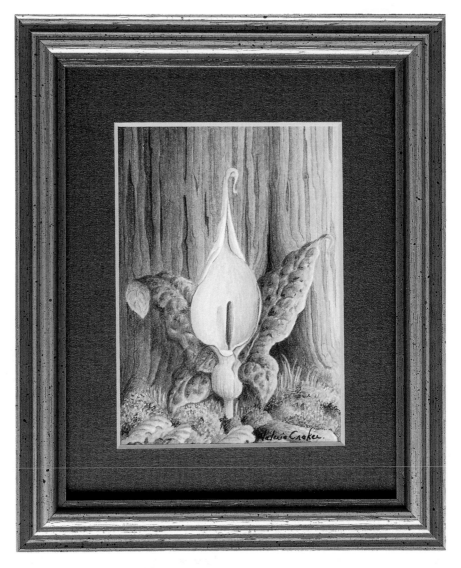

16. The final painting is perfectly
presented against dark green and gold.

The Swan

ROBERT HUGHES
2 ¾ x 2 ¼ INCHES; GOUACHE ON PAPER

*Robert Hughes chose 140-pound hot
pressed (HP) paper for this painting,
and his palette included permanent
white, yellow ocher, burnt sienna,
burnt umber, sepia, ultramarine blue,
cerulean blue, permanent green, deep
blue, and black. The composition was
based on a photograph, and before he
began Robert Hughes marked the size
of the finished painting on the paper.*

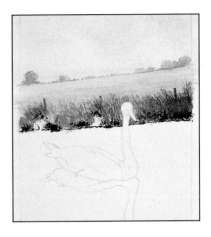

2. Further washes are applied to the
distant field, and details are added to the
long grass and posts in the middle ground.

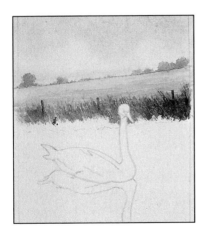

1. The outline is lightly drawn in a hard
pencil, and the sky is washed in with a
touch of cerulean blue, with the clouds
being lifted out with a dry brush. The base
of the clouds are a pale wash of burnt
sienna and ultramarine blue. The field is
painted in a wash of green and yellow
ocher, and when it is dry the trees are
painted in ultramarine blue and a little
yellow ocher. Some of the middle ground is
also painted.

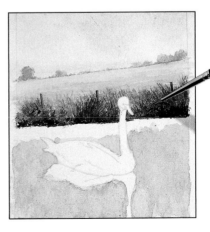

3. The detail of the bank is completed,
and the first wash of cerulean blue and
burnt umber is laid in the area of the water.

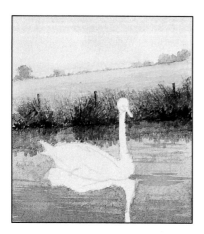

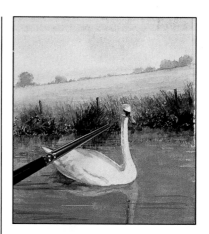

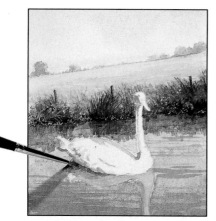

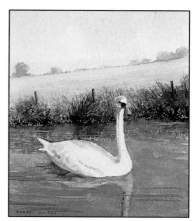

4. The reflections of the bank undergrowth are shown in green and sepia. Further washes of cerulean blue and burnt umber are added to the water, with the strength of color being gradually increased.

5. The swan's body is formed by painting the shadows in ultramarine blue and a touch of black, applied very thinly. The reflection of the swan is defined in ultramarine blue and burnt sienna.

6. A very fine sable brush, a no. 000, is used to add the details to the swan. The paint is used thickly, and gouache's ability to cover other colors is used to good effect on details such as the beak and feathers.

7. The final details are added to the swan and to the bank. Flowers can be introduced by simply using a fine brush laden with full-strength paint.

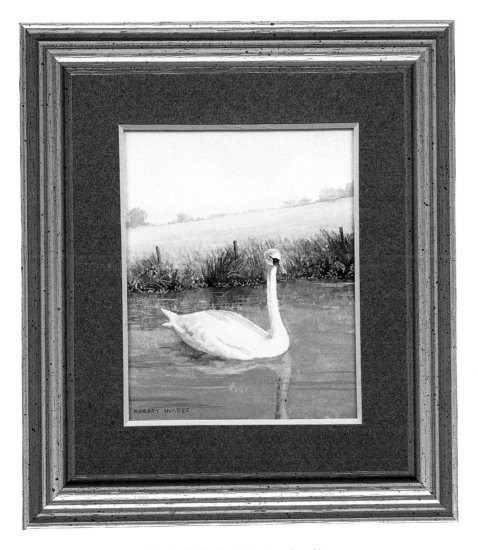

8. The finished painting is enclosed in a dark mat to complement the delicate color of the main subject.

The Artists

Heather O. Catchpole
HSF, RMS, HS

Known throughout the world for her animal portraiture, especially her paintings of dogs, Heather Catchpole has a natural love of all animals, and she spends considerable time getting to understand the personalities of her subjects – and of their owners – before beginning work.

She originally comes from Vancouver Island, but trained in graphic arts in Durban, South Africa. She lived and worked in Johannesburg in the 1960s before moving to Britain, and she now lives in Somerset with the two cocker spaniels that often feature in her work. She began painting animal portraits in average size, mostly using pastels. Like many miniaturists, her love of the art began during a visit to an exhibition of the RMS, since when she has concentrated on miniatures, using watercolor on ivorine. She tests the colorfastness of paints by exposing them to light on a piece of ivorine, which she leaves on a windowsill in her studio, and she uses only those colors that stand up well to this test.

She studies her subjects thoroughly, producing a series of detailed pencil sketches to the size of the proposed finished portrait, and she adds notes on colors, supplementing this information with photographs.

Heather Catchpole lectures on the history of English portrait miniatures, and is also an expert on silhouettes. Her enthusiasm for miniatures led her to become a founder member of the Hilliard Society, and she still serves on the council that organizes the Society's activities. She is also a full member of the RMS.

Valerie Croker
SBA, HS

After studying at Maidenhead Art School and Reading University, Valerie Croker used her artistic talents in the fields of dressmaking and embroidery collage, returning to painting only when her children had grown up. Her works, which have been extensively reproduced on tableware and greetings cards, have been exhibited in the Mall Galleries, England, and with United Artists, and were accepted by the Society of Botanical Artists in only the second year of open submission. In the early 1980s she was commissioned to illustrate four books on the countryside and folklore. For most of her professional life she has worked on larger pictures, but her meticulous style and careful attention to detail lend themselves perfectly to miniatures, and she is now a member of the Hilliard Society.

Although much of her work is on a large scale, she prefers to experiment by concentrating on a small area and working it up. She uses no special equipment for the transition from large to small. She did try using a magnifying glass, but found it difficult to judge the distance between glass and paper, so she no longer uses one. As she gets older, she says, and as her

eyesight has less depth of focus, she finds it easier to paint on a small scale.

She now lives in the English countryside, which provides endless inspiration for the botanical and wildlife watercolor paintings in which she specializes.

Pauline Gyles
FSBA, RMS, HS

After leaving school with no formal art training, Pauline Gyles began work for a photographic company as a hand-colorist of portrait photographs to make them resemble paintings, a job that came to an end when color film became widely available. She started to attend art classes, and found that her aptitude for working in detail and on a small scale was ideal for working in miniature. In 1975 she submitted her work to the RMS, and became ARMS in 1981 and RMS in 1985. She has won two Gold Bowl honorable mentions and second prize in the Fairman Subject Miniature Award in 1990, and she is now honorary secretary of the RMS. She was a founder member of the Society of Botanical Artists. She joined the Hilliard Society in 1985, and won the Bell Award for the best portrait miniature in 1991.

As well as portraits, Pauline Gyles enjoys painting still-life subjects, and she specializes in watercolor on ivorine. She carries out much work to commission, and her work is displayed at galleries throughout Britain. She is at present living and working in Poole, Dorset.

Robert Hughes
RMS, HS, SM

Robert Hughes was born in London, but he now lives in Wiltshire, surrounded by the beautiful countryside that inspires so many of his landscape paintings. He began painting professionally in 1982, despite having had no formal art training, and resigned from a successful business career in 1991 so that he would have time to meet the demand for his miniatures.

His early work was on large canvases, but his interest in miniatures arose when the financial demands of bringing up a family made him look around for smaller, more economical media, and he found that he could naturally work in a miniature style, even though he knew little about the art at first. A local gallery owner spotted his work, and the miniatures soon became bestsellers. In 1986 his talent was recognized by the Royal Miniature Society when he was appointed an associate member; he gained his full membership in 1989. He has been a member of the Hilliard Society since 1986, and of the Society of Miniaturists since 1991.

He is well-disciplined in his work, setting himself targets that he normally achieves. Presentation is an important aspect, and he always chooses a frame that will complement the painting. He achieves the detail without the aid of a magnifying glass, but he supplements natural light by focusing the light of two small table lamps on his work. Listening to Mahler and Schumann helps him get in the mood to paint. He visualizes the scene in his mind before transcribing the image to prepared board, but he also works from photographs and always carries a camera with him, never missing an opportunity to capture a suitable composition.

Commander Geoff Hunt
RMS, HS

Although he wanted to be an artist when he was young, Geoff Hunt sought a career in the Royal Navy. After 40 years he left the Navy, but spent the next three years as superintendent of the Hong Kong Sea School. Only then did he return to Britain to devote more time to painting.

As a sailor and artist, Geoff Hunt combines the traditions of marine art and miniature painting with distinction. In the 18th and 19th centuries, naval officers were taught to paint and sketch so that they could record details of enemy ships and shore fortifications. The obligation to illustrate midshipmen's journals sometimes released in later naval officers a latent talent that, as with Geoff Hunt, was developed over many years at sea. As Geoff Hunt points out, artistic license is an essential ingredient of art, but it must be eschewed when it comes to recording historical events or matching the set of a sail against the elements. His battle and ocean racing scenes are carefully researched, with details derived from contemporary pictures and prints, although ship dispositions are based on the more reliable evidence of eyewitness accounts or tactical maps. The resulting authenticity and accurate details appeal as much to the yachtsman as to the art collector.

Although his first love is the sea and ships, Geoff Hunt's works extend over a range of subjects, including portraiture, architecture, birds and animals, flowers, and an occasional vintage car or aircraft. He prefers to paint on functional objects, such as antique boxes, pocket magnifying glasses, and jewelry, which can be either worn or displayed. His work is mostly undertaken on commission from private collectors or corporations. He exhibits regularly with the Royal Miniature Society, the Hilliard Society, and a number of British galleries.

Eric J. Morton
RMS, HS

Eric Morton has always enjoyed painting, but it was not until the 1960s that his wife encouraged him to join a local art group and take his hobby more seriously. He has been painting on a full-time basis since 1989.

He had always been interested in fine work, and his first career, as a maker of electronic instruments, required dexterity and attention to detail. His first works were average in size, and his favorite subjects are taken from nature. He started to experiment with smaller paintings in 1986 after a visit to an exhibition of the Hilliard Society. Two years later he won the Best Novice award, and in 1989 he was joint Best in Exhibition. In 1989 he entered his work for the RMS exhibition, becoming ARMS in 1990 and RMS in 1993, when he also won the Llewellyn Alexander subject miniature award. His work may be seen in the Medici Gallery and the Llewellyn Alexander Gallery, both in London.

Eric Morton enjoys the tightness and control necessary in achieving a classic miniature. He used only light-fast paints and works on acid-free paper, because he feels that people who buy the paintings deserve the best possible materials.

He works on a slightly sloping surface, using stretched paper to avoid cockling. At first he used a magnifying glass, but has now invested in a head-mounted magnifier. His board is placed directly under a large window so that he can work in natural light whenever possible, but he uses daylight bulbs when necessary.

Frederick Cameron Street
HS

During the London bombing of WW II, Frederick Cameron Street was evacuated to Devon, where he lived for many years. After a brief period in Australia he returned to Britain and now lives in Wiltshire. Although he was interested in art at school, it was not until 1981 that he began to develop his talent by attending art classes; two years later he held a one-man show.

His interest in miniatures was generated by an invitation to an exhibition of the Royal Miniature Society. He finds the change from painting large-scale works to miniatures exciting. Initially, the main difficulty he experienced was with the placing of a composition on paper. Restriction of movement was also a problem, because he is naturally a flamboyant painter. He uses a magnifying glass, which makes his miniatures look like large paintings while he is working on them and gives him a greater feeling of movement. He uses daylight bulbs to provide additional concentrated light while he works.

His open, loose style is unusual for a miniaturist, but it encourages the viewers to use their imagination to see more in the paintings than is actually detailed, thus making the viewers play their part in the composition. Frederick Cameron Street considers that a miniature painting requires more skill and preparatory thought than a large-scale work, comparing the skills involved in conveying a lot of meaning in a small space with those required to write a short story rather than a full-length novel.

His was accepted as a member of the Hilliard Society in 1991 and has subsequently exhibited miniatures at the Llewellyn Alexander Gallery, London.

Barbara Valentine
NDD, ARMS, HS

Barbara Valentine trained in illustration at Goldsmiths' College School of Art and was awarded a National Diploma in Design in 1964. After working in various branches of art, she was introduced to miniatures by a friend and has concentrated on them ever since. She teaches an adult evening class, and her miniatures have won awards at the Hilliard Society, the miniature exhibition of the Llewellyn Alexander Gallery, London, and the Ulster Society of Miniaturists. Her work has also been accepted for the Royal Academy Summer Exhibition in 1991–3.

She belives that studying and copying early miniatures is the best way to learn the techniques. She works in a custom-built studio filled with the objects she has collected over the years to use in her still-life paintings. The intricate meanings of her work are expressed in the objects themselves, and in the ways in which they are arranged together.

Barbara Valentine tries to keep all parts of the painting at the same stage of work, rather than finishing one aspect first, so that she can more easily judge if small adjustments should be made to position, tone, or color. She usually paints in watercolor and, occasionally, oil on ivorine or on vellum, and she has found that the backs of unwanted photographs provide an excellent surface for experimenting with colors and techniques. She tends to use Winsor & Newton pans for darker colors, and tubes for lighter ones; she uses very little white, and black is only used for silhouettes. Her favorite brushes for fine detail are Da Vinci Needlepoints.

Societies

The art of miniature painting is becoming increasingly well-organized, and there are many societies throughout the world that can offer advice to prospective members.

United Kingdom

ROYAL SOCIETY OF MINIATURE PAINTERS, SCULPTORS, AND GRAVERS (RMS)
Founded in 1895, the society holds an annual exhibition in November/December in Westminster Gallery, Westminster Central Hall, London.
Contact: The Executive Secretary, Burwood House, 15 Union Street, Wells, Somerset BA5 2PU.

SOCIETY OF MINIATURISTS (SM)
There are two exhibitions in Ilkley, Yorkshire each year, in June/July and November/December. Contact: Leslie Simpson, Society of Miniaturists, 41 Lister Street, Riverside Gardens, Ilkley LS19 9ET.

HILLIARD SOCIETY (HS)
Members from all over the world. The society organizes an annual exhibition in June in Wells, Somerset. Contact: The Hilliard Society of Miniaturists, 15 Union Street, Wells, Somerset BA5 2PU.

SOCIETY OF LIMNERS
There is an annual exhibition of members' work; membership is by election, and the society hopes to extend its activities from the southeast. Contact: Colleen Melmore, Executive Secretary, The Society of Limners, 104 Poverest Road, Orpington, Kent BR5 2DQ.

THE ULSTER SOCIETY OF MINIATURISTS
Contact: The Secretary, 7 Lowery Hill, Bangor, County Down, Northern Ireland BT19 1BX.

United States

MINIATURE ARTISTS OF AMERICA
Contact: Kay Petryszak, 1595 N. Peaceful Lane, Clearwater, Florida 34616.

GEORGIA MINIATURE ART SOCIETY INC.
Ms. Meredith Rambo, 3922 Butterfield Drive NW, Kennesaw, GA 30144.

THE MINIATURE ARTS SOCIETY OF FLORIDA
Doris Liverman, 1813 Driftwood Circle N, Oldsmar, Florida 34877.

WASHINGTON SOCIETY OF MINIATURE PAINTERS, SCULPTORS, AND GRAVERS
Mrs. Margaret Hicks, 1607 Crittenden St. NW, Washington DC 20011.

Australia

THE AUSTRALIAN SOCIETY OF MINIATURE ART
Contact: Colin Peck, Membership Secretary, Buckenham, Darwalla Road, Mont Natan, via NERANG, Queensland 4211.

South Africa

SOUTH AFRICAN MINIATURE SOCIETY
Contact: Jeff Sochen, 8 Cotton Road, Greenside 2193, Johannesburg.